MW00450462

Traditional
CHINESE LATTICE
DESIGNS

Muncie Hendler

DOVER PUBLICATIONS, INC.
New York

Copyright

Copyright © 1995 by Dover Publications, Inc.
All rights reserved under Pan American and International Copyright Conventions.

Published in Canada by General Publishing Company, Ltd., 30 Lesmill Road, Don Mills, Toronto, Ontario.
Published in the United Kingdom by Constable and Company, Ltd., 3 The Lanchesters, 162–164 Fulham Palace Road, London W6 9ER.

Bibliographical Note

Traditional Chinese Lattice Designs is a new work, first published by Dover Publications, Inc., in 1995.

DOVER *Pictorial Archive* SERIES

This book belongs to the Dover Pictorial Archive Series. You may use the designs and illustrations for graphics and crafts applications, free and without special permission, provided that you include no more than four in the same publication or project. (For permission for additional use, please write to: Permissions Department, Dover Publications, Inc., 180 Varick Street, New York, N.Y. 10014.)

However, republication or reproduction of any illustration by any other graphic service, whether it be in a book or in any other design resource, is strictly prohibited.

Library of Congress Cataloging-in-Publication Data

Hendler, Muncie.
 Traditional Chinese lattice designs / Muncie Hendler.
 p. cm. — (Dover design library)
 ISBN 0-486-28699-1 (pbk.)
 1. Latticework—China. 2. Repetitive patterns (Decorative arts)—China. I. Title. II. Series.
 NK1483.A1H47 1995
 745.4′4951—dc20 95-7441
 CIP

Manufactured in the United States of America
Dover Publications, Inc., 31 East 2nd Street, Mineola, N.Y. 11501

PUBLISHER'S NOTE

The Chinese have used lattice designs in windows for approximately 3,000 years. Although the purpose of the lattice is functional (to support oiled paper stretched across the wooden members), it has developed considerable design value.

For the present volume, Muncie Hendler has rendered lattice designs that are particularly suitable as allover patterns for graphics projects. They can be used directly as reproduced or altered to meet specific needs.

The reader interested in additional lattice designs is referred to two other works, both by Daniel Sheets Dye and published by Dover Publications: *Chinese Lattice Designs* (0-486-23096-1) and *The New Book of Chinese Lattice Designs* (0-486-24128-9).

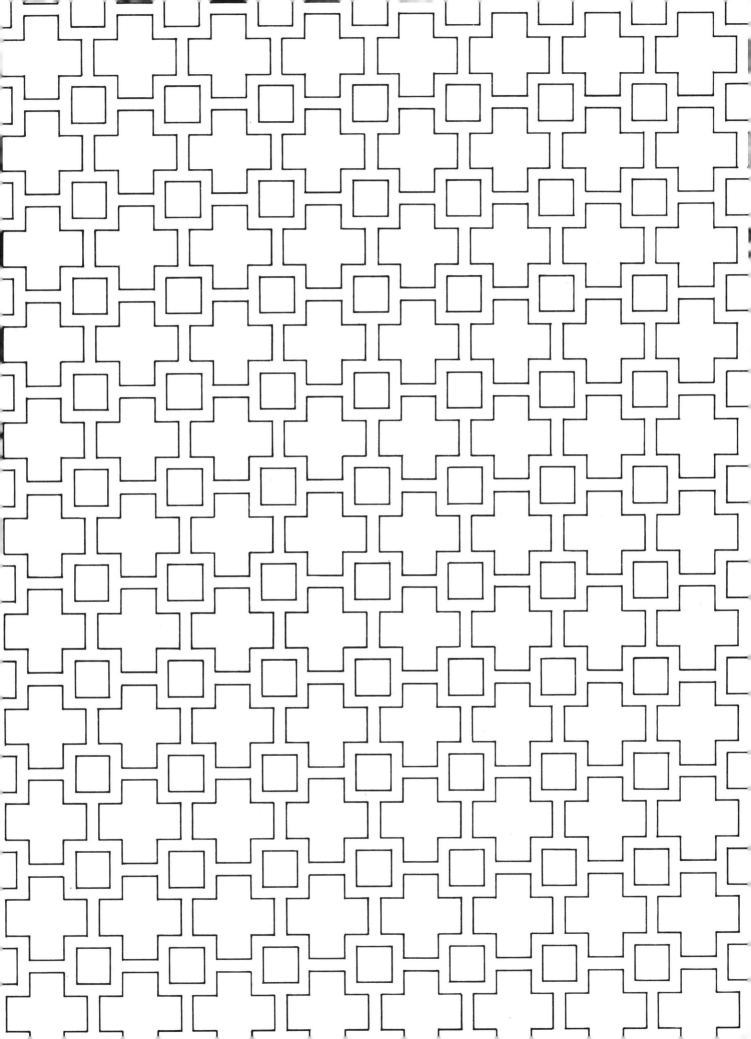

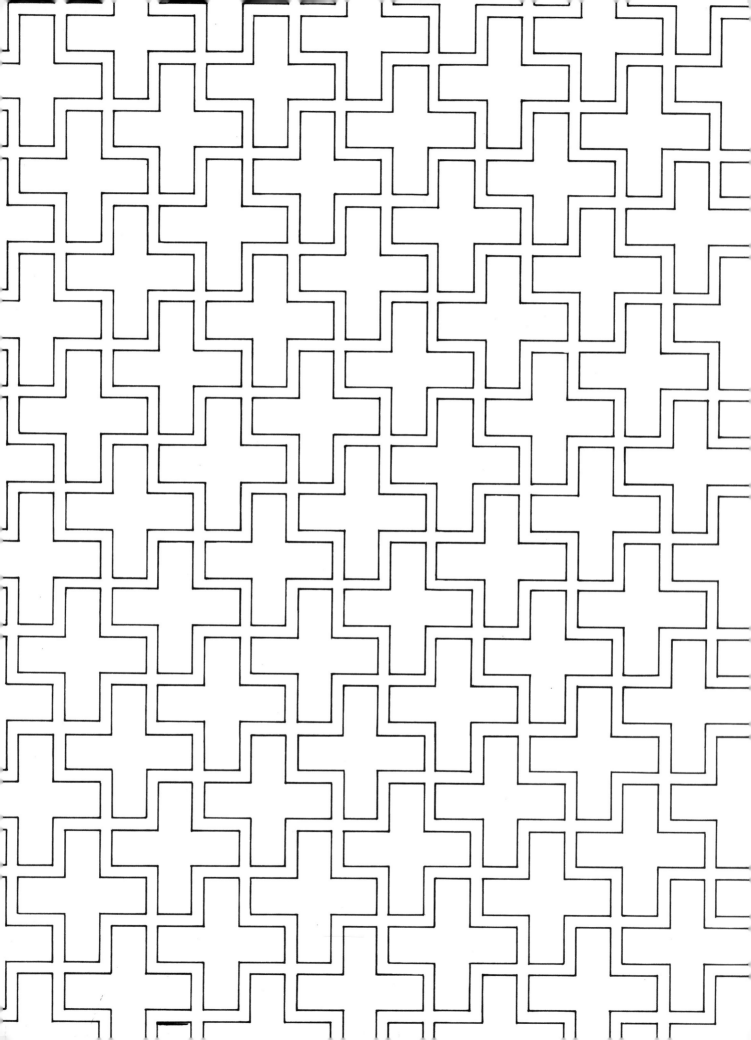

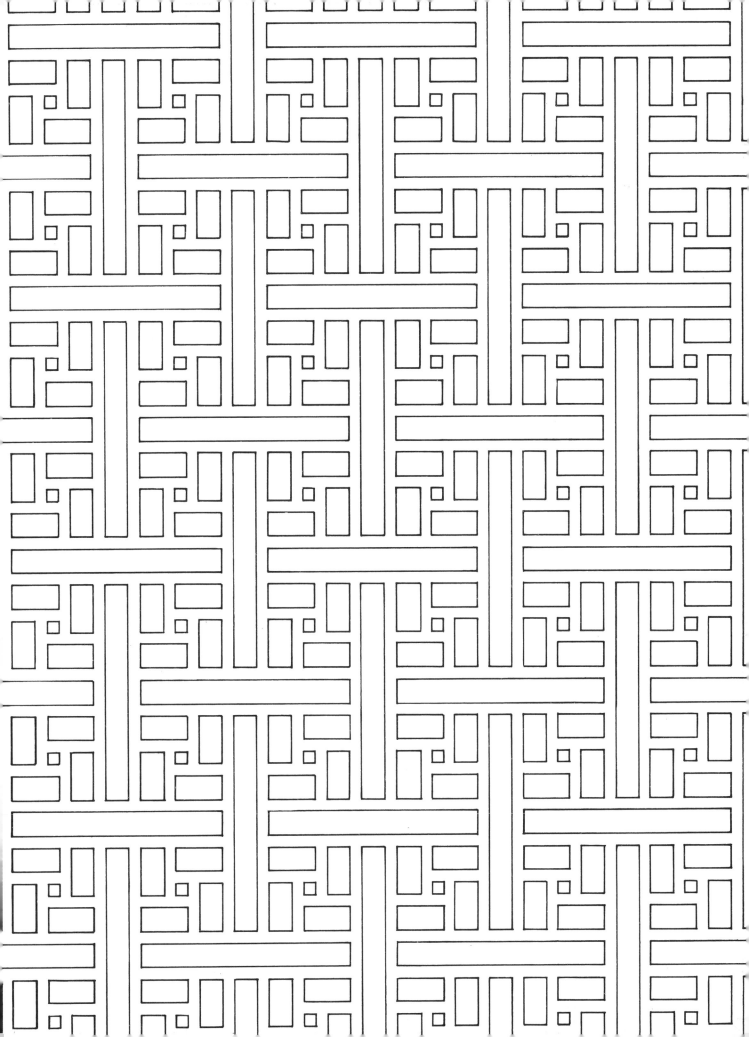

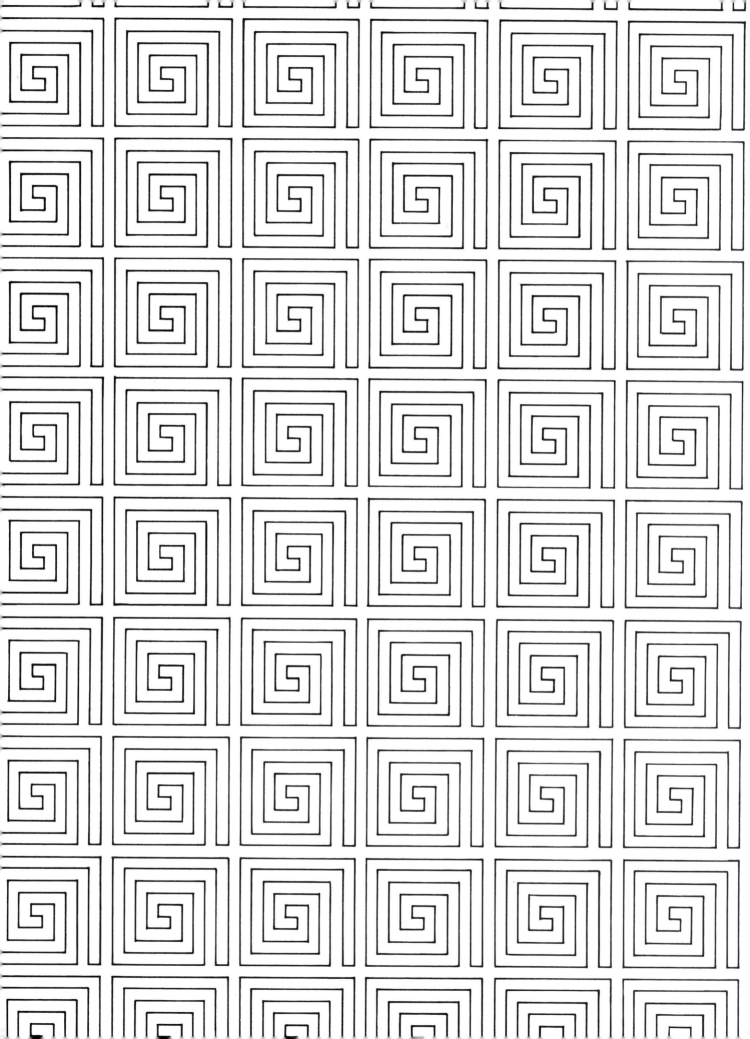

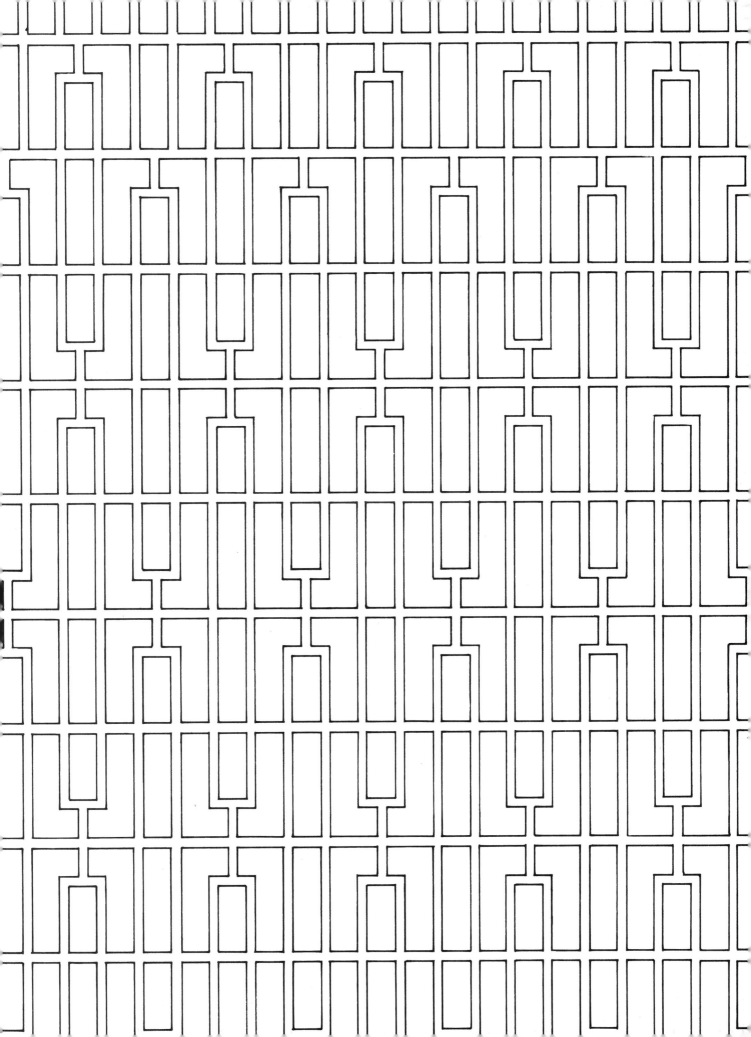

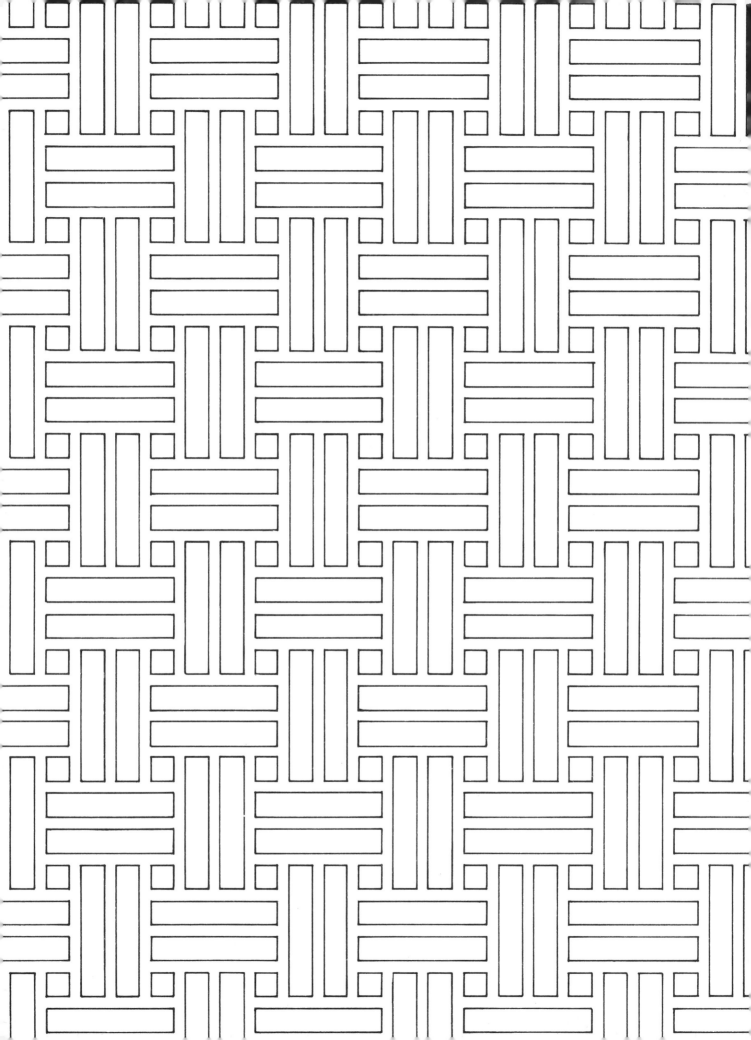

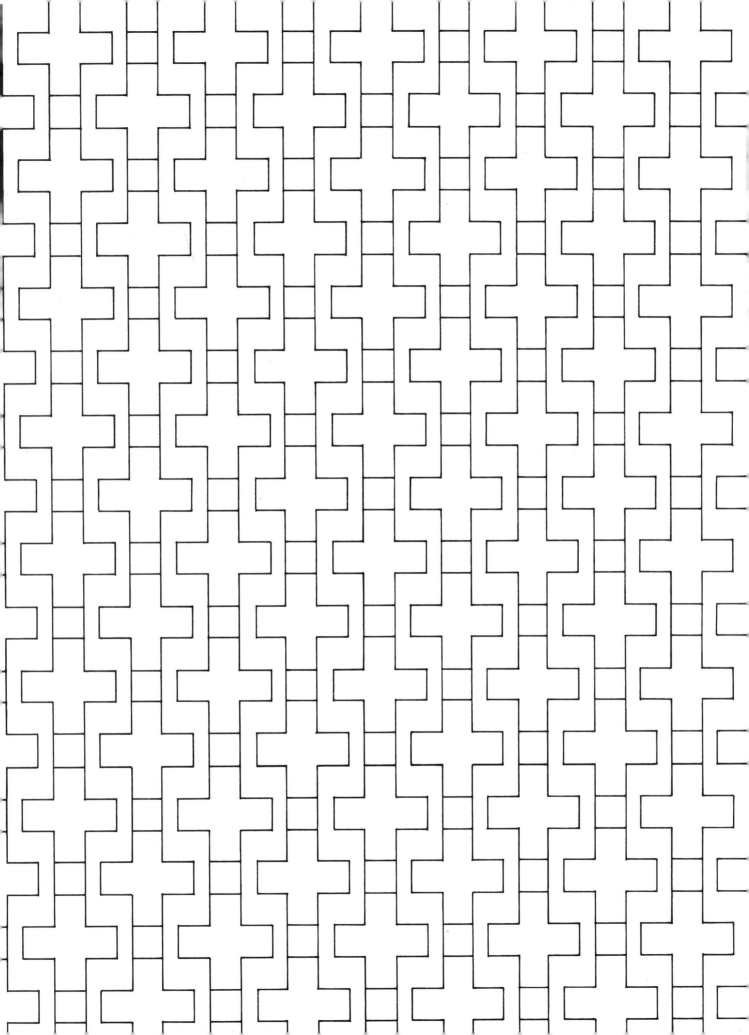

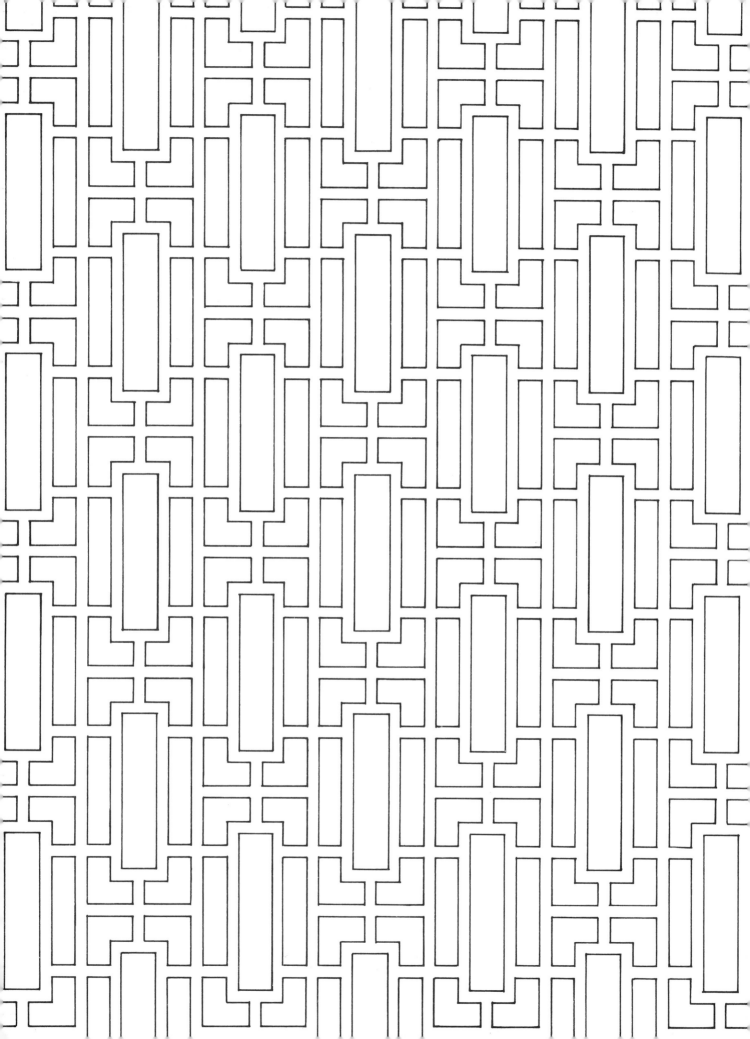

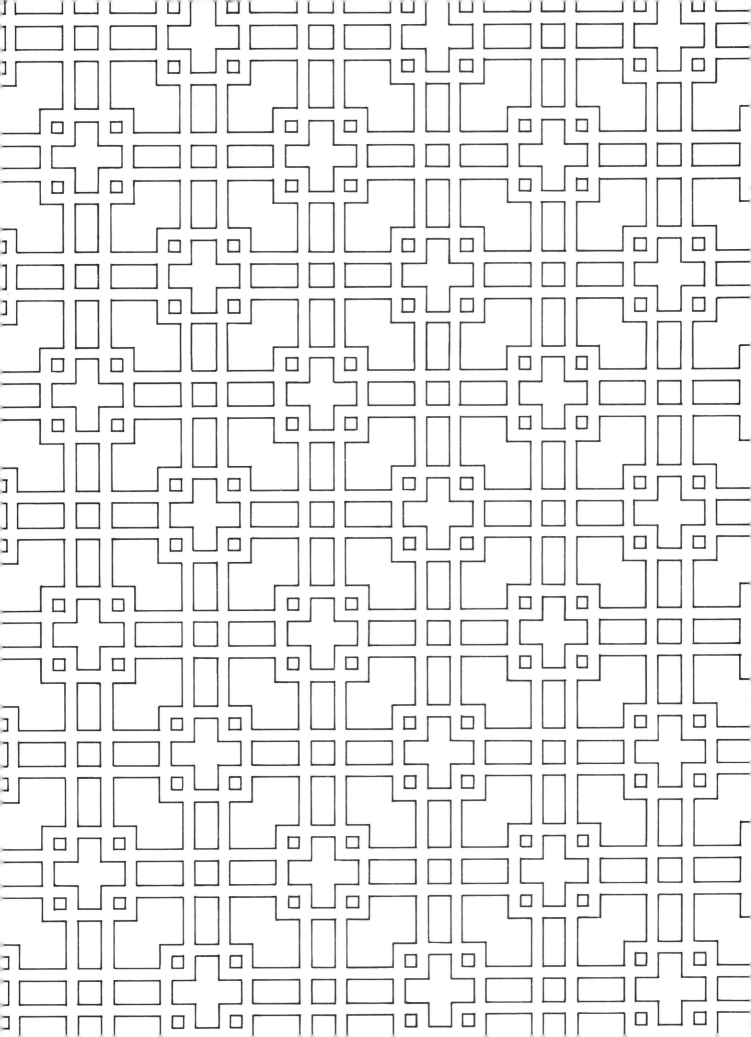

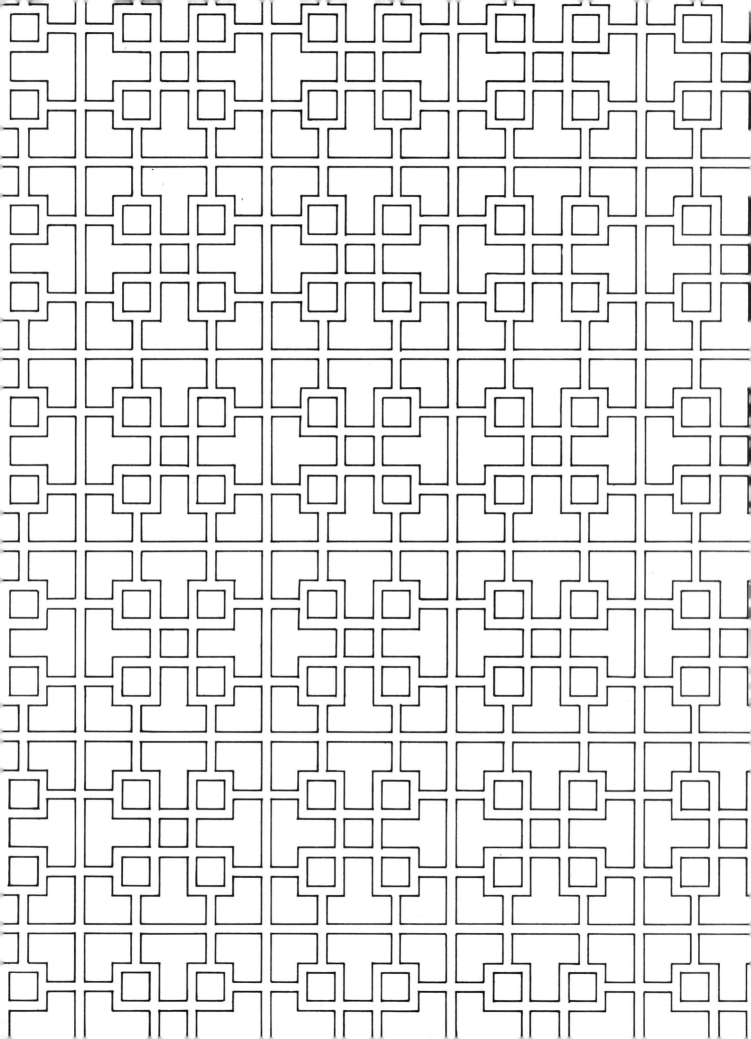

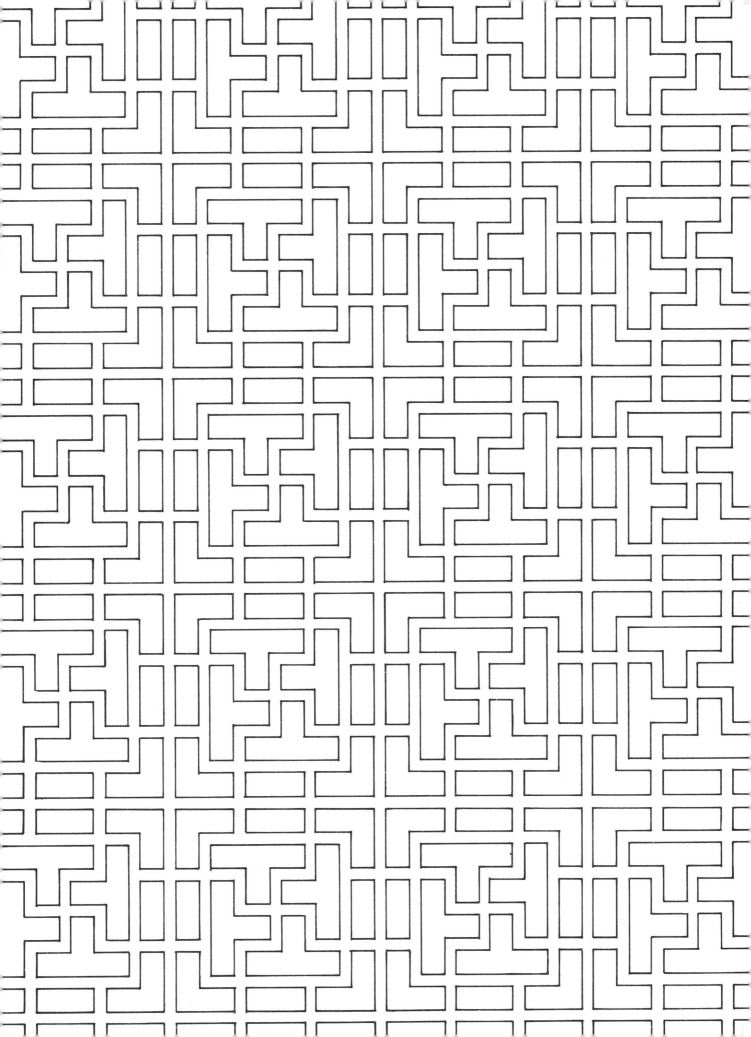

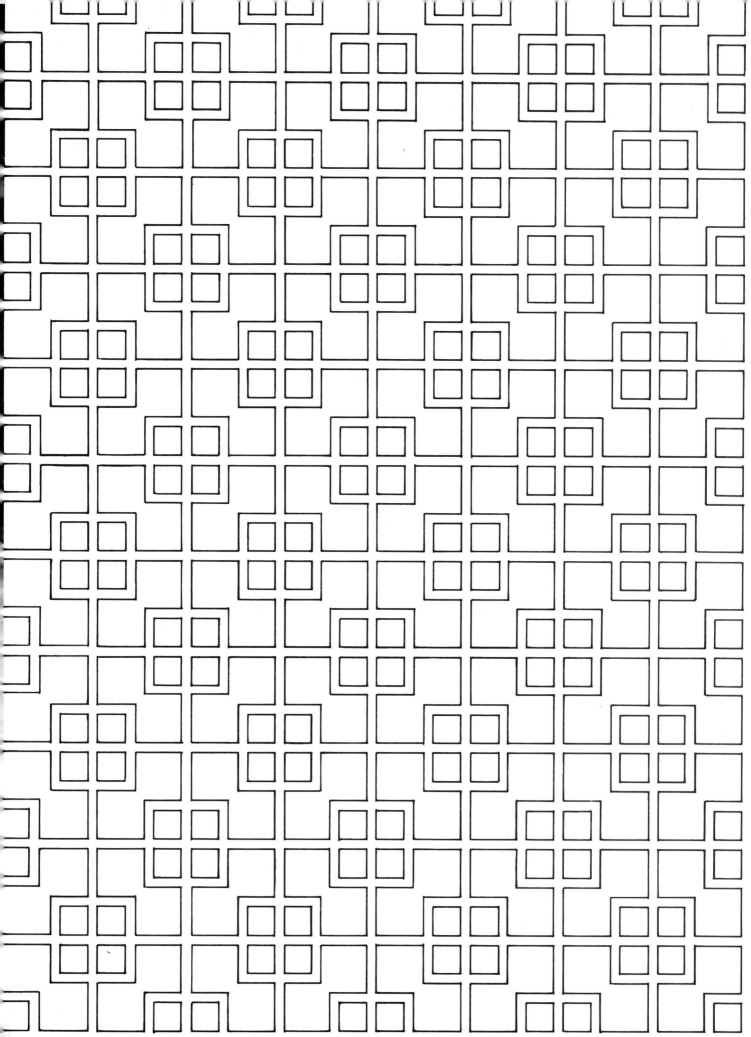

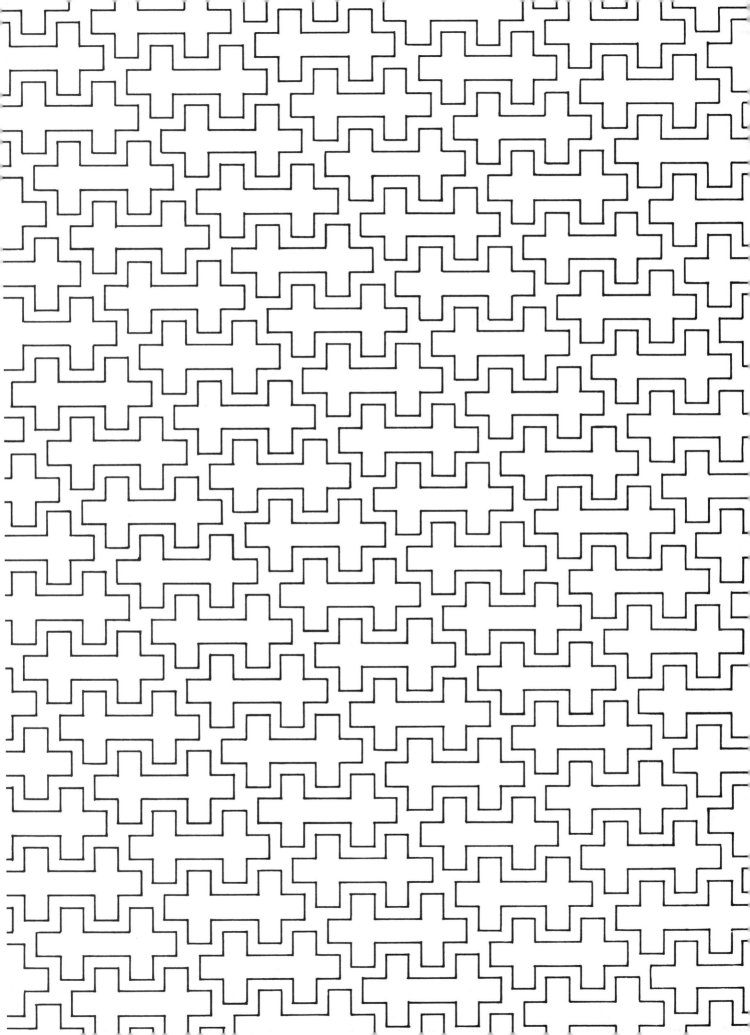

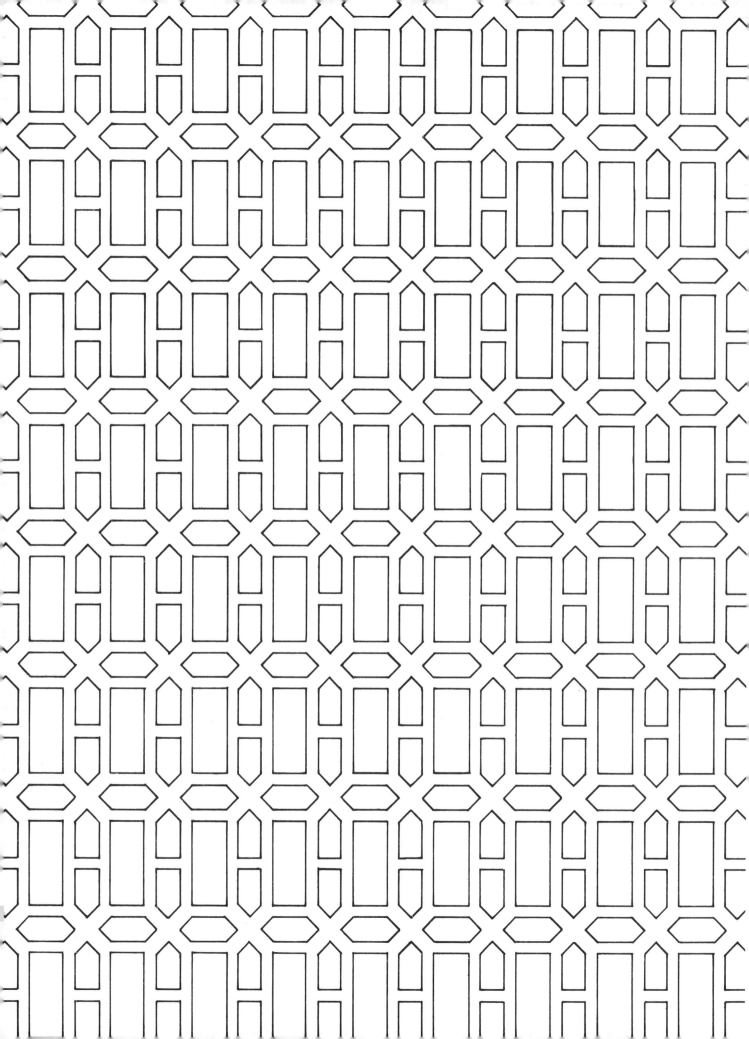

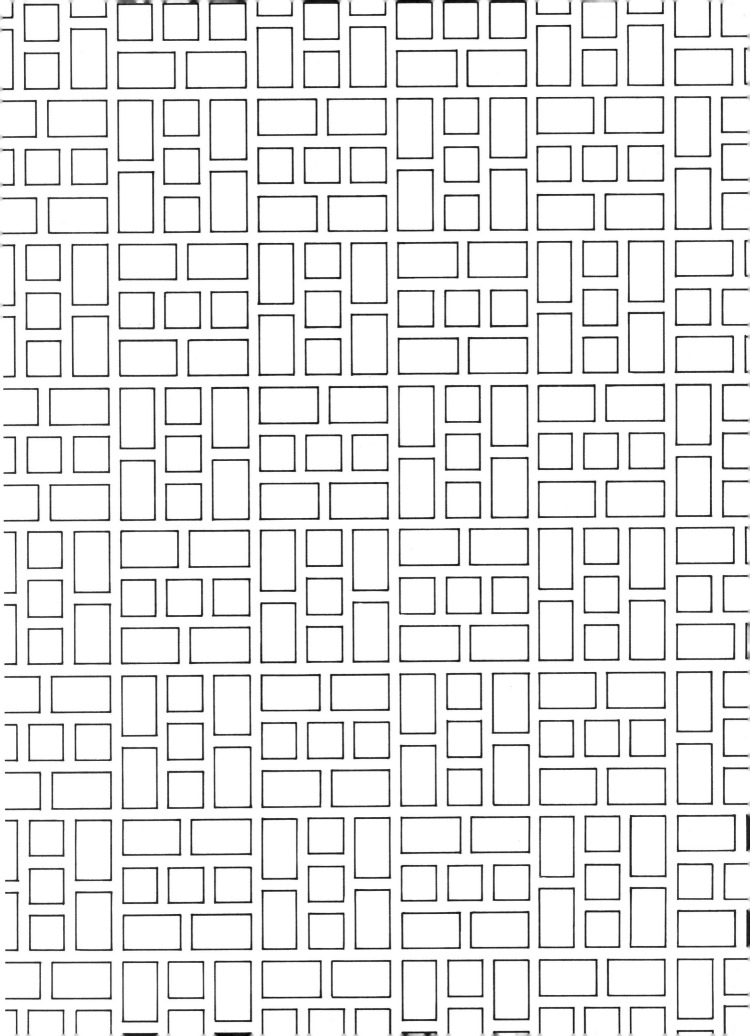

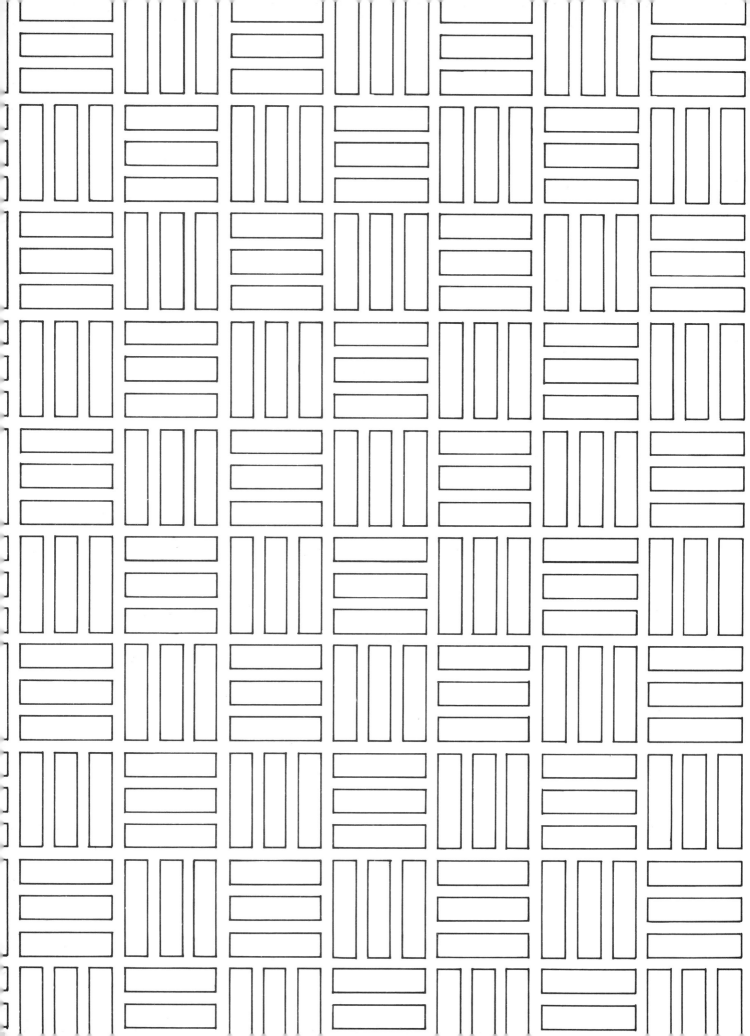

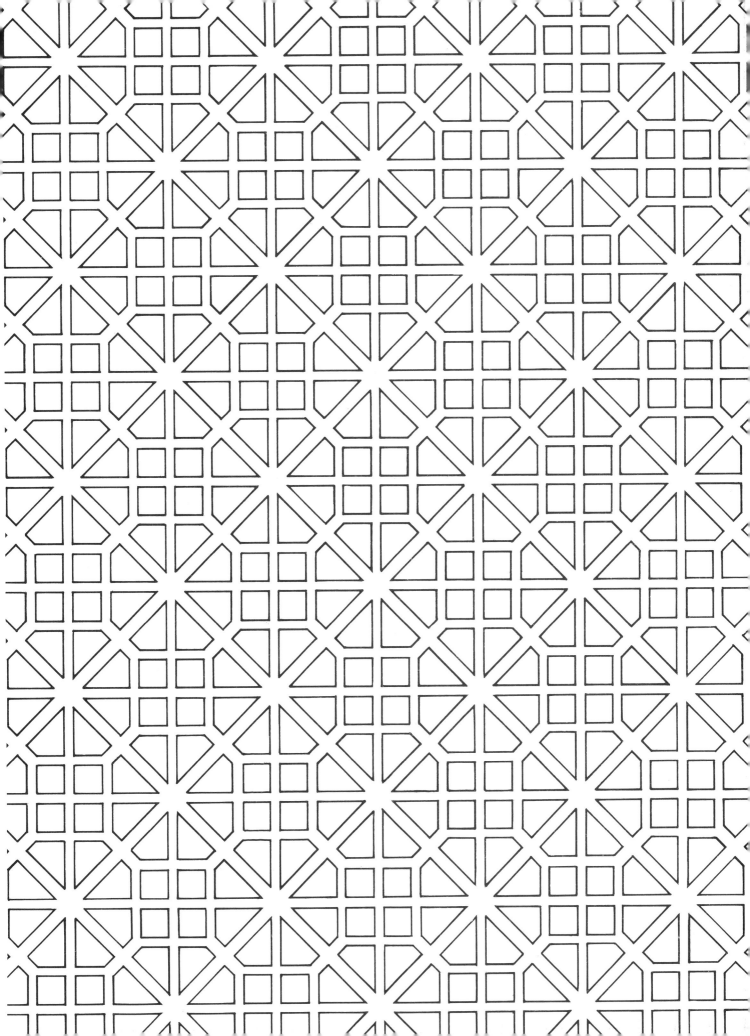

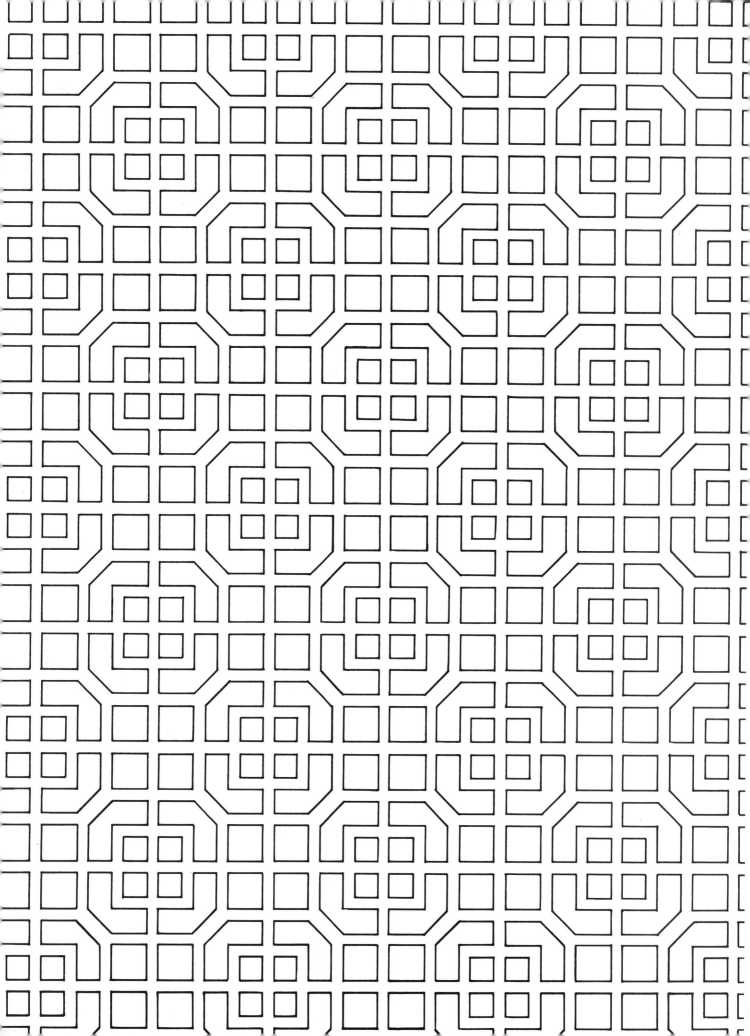

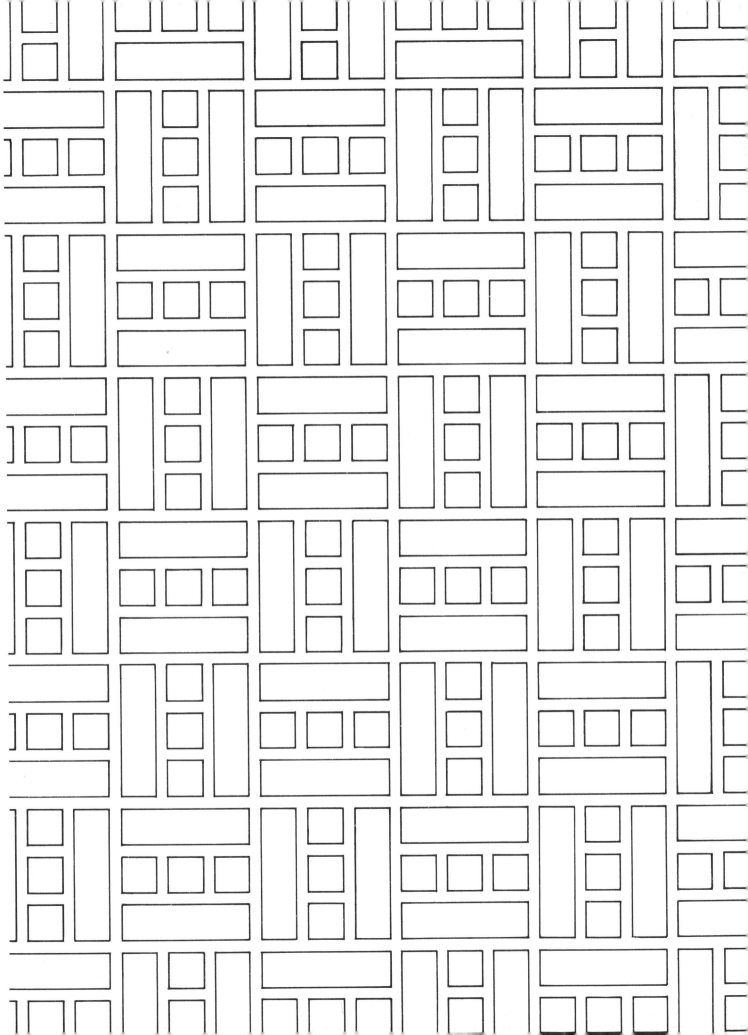

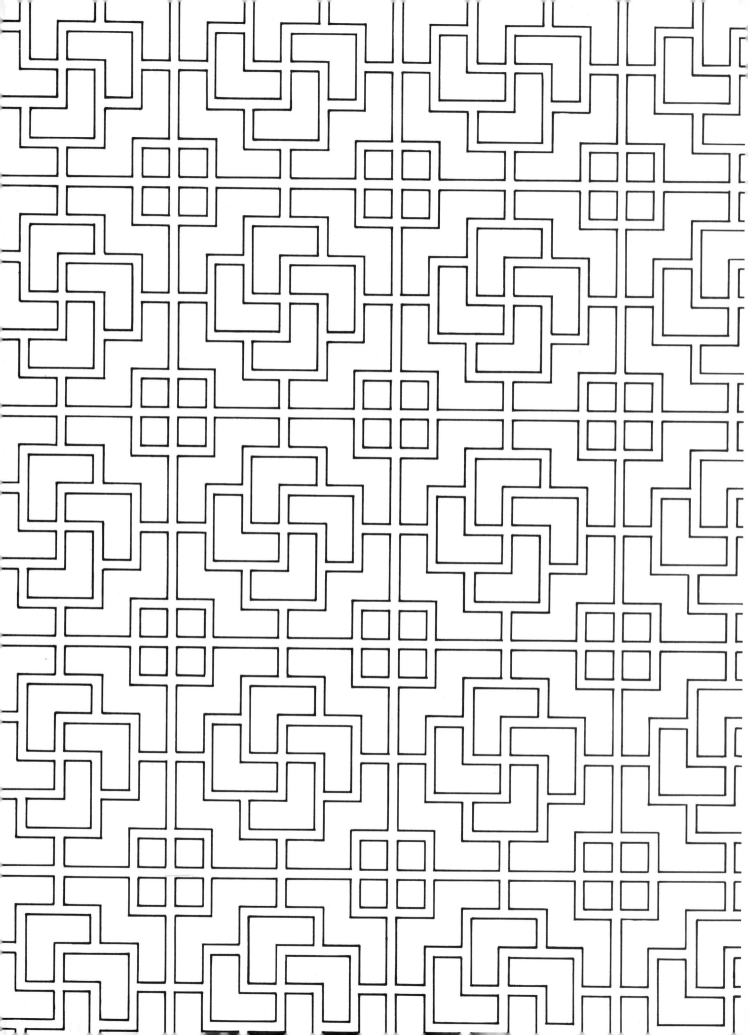

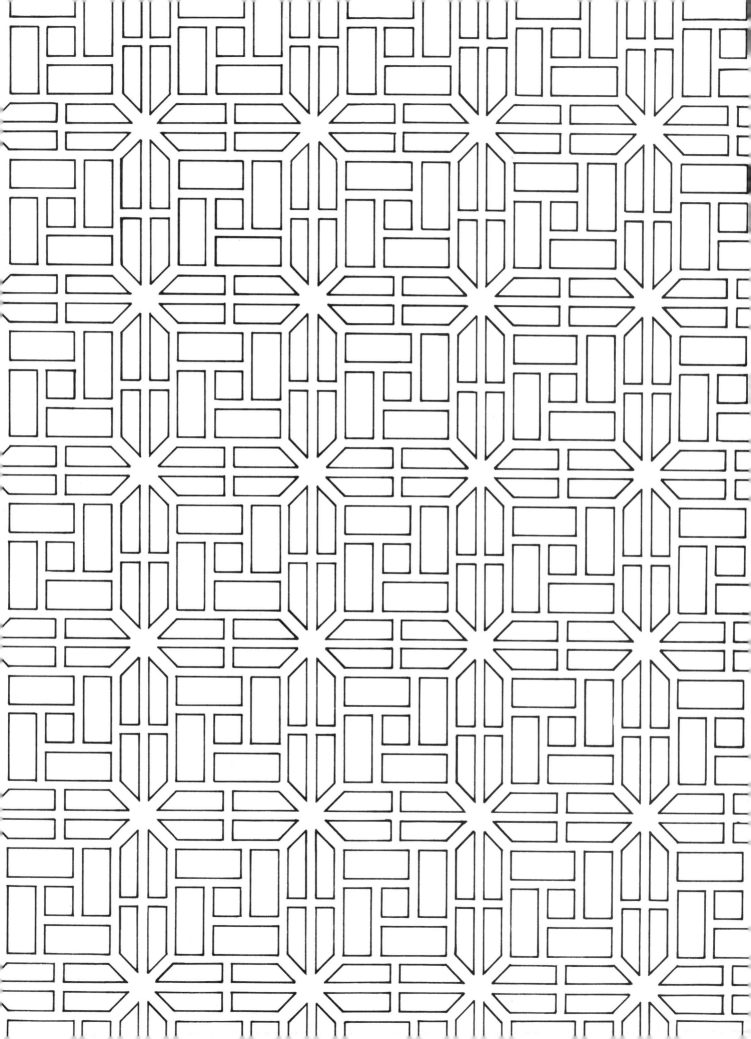

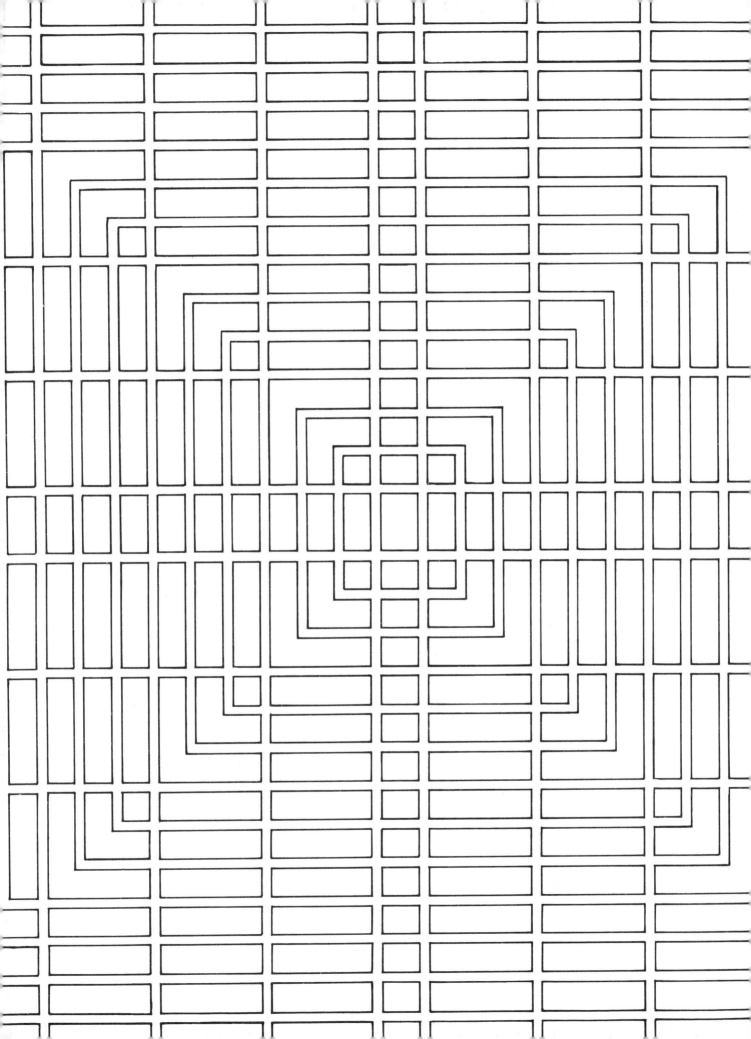

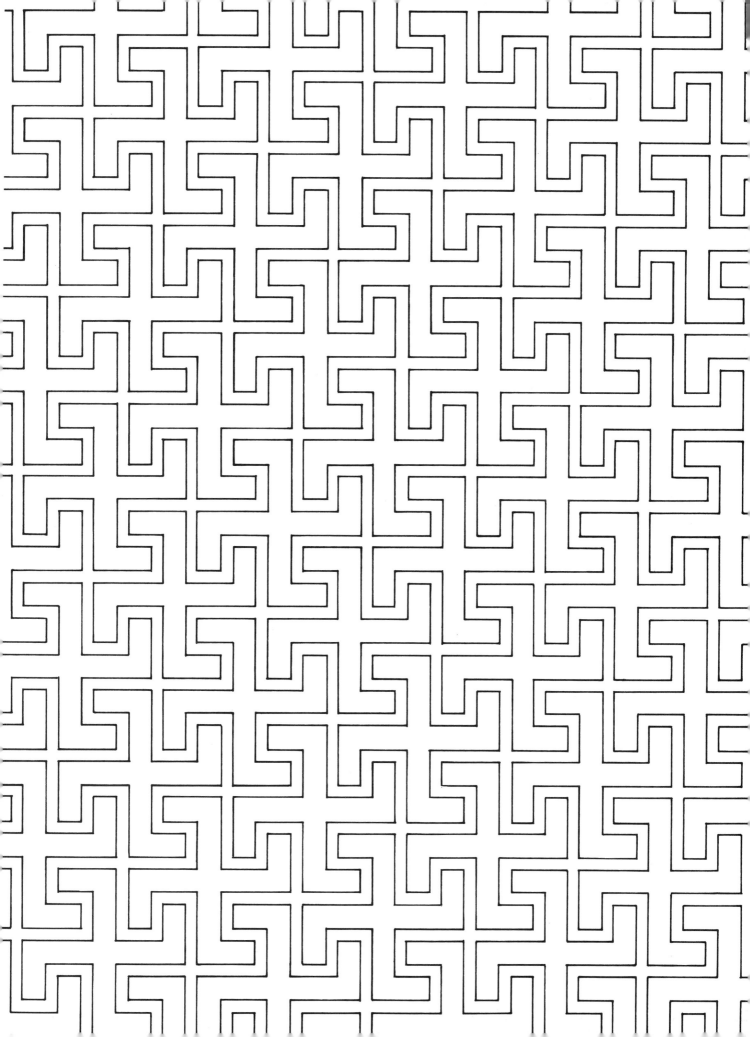

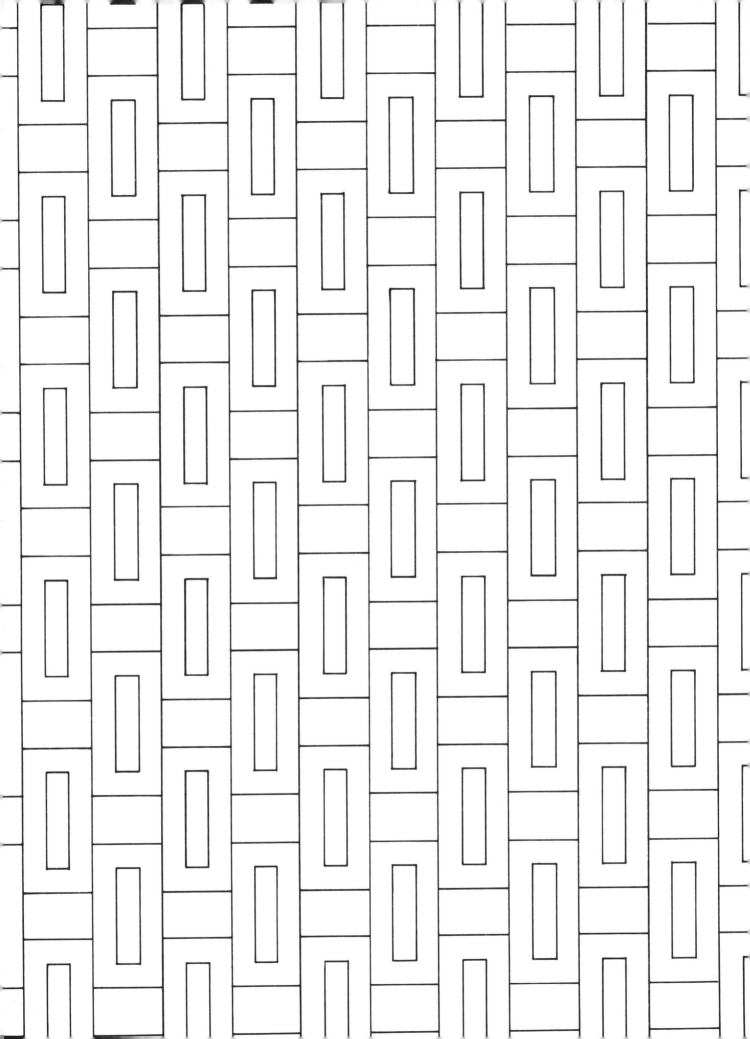

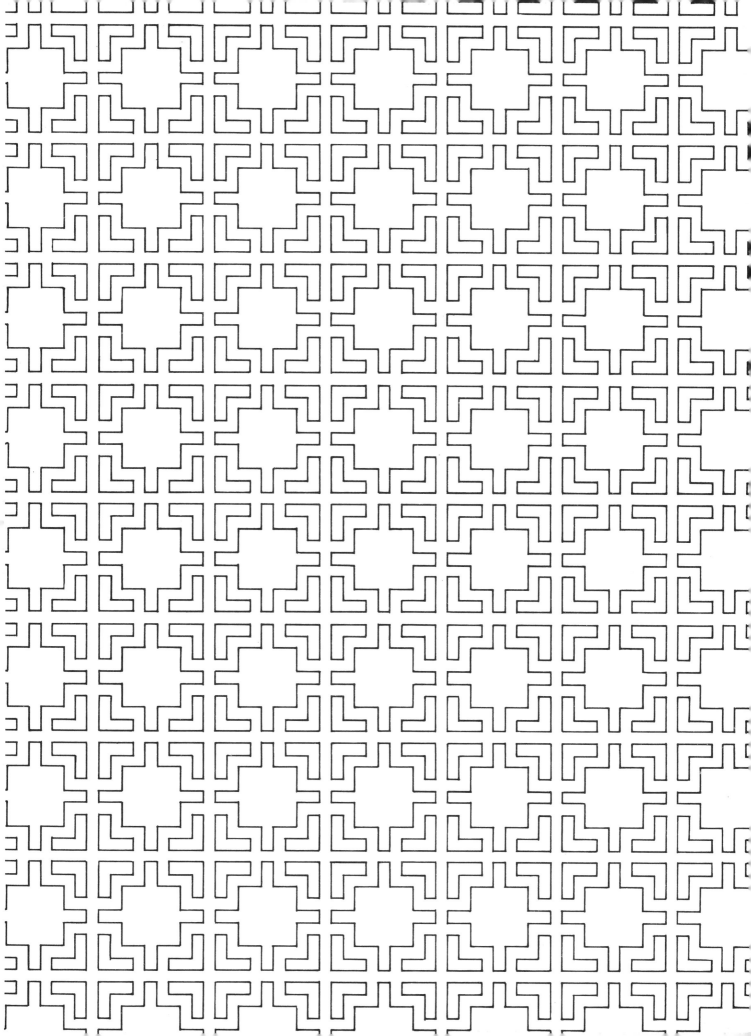

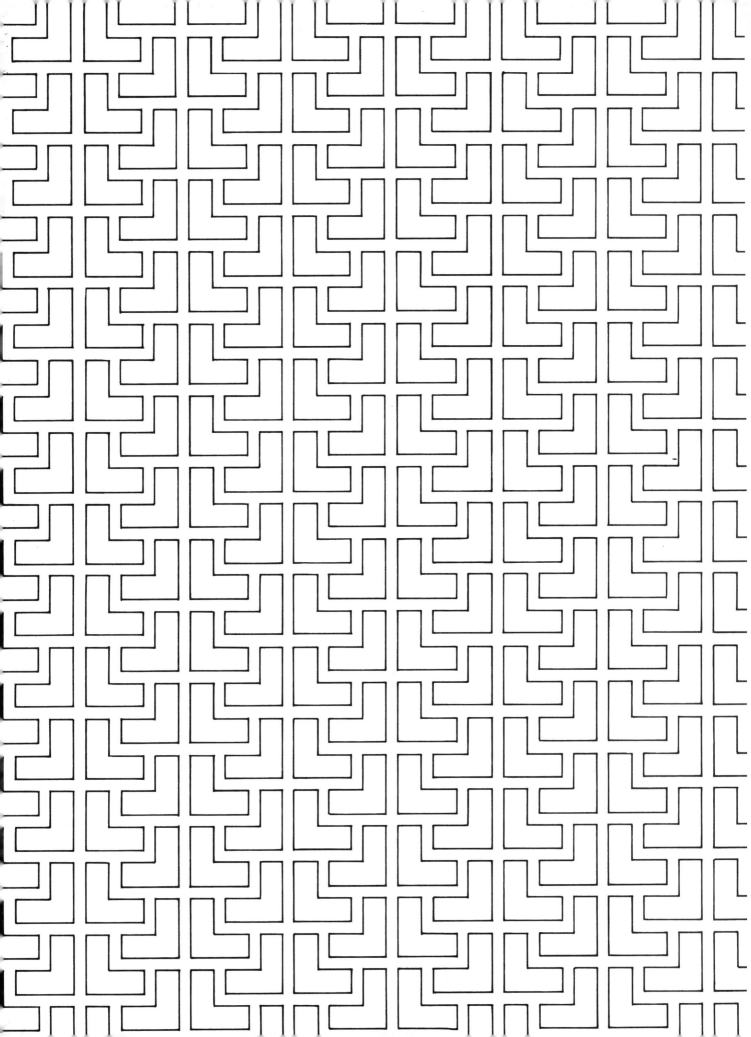

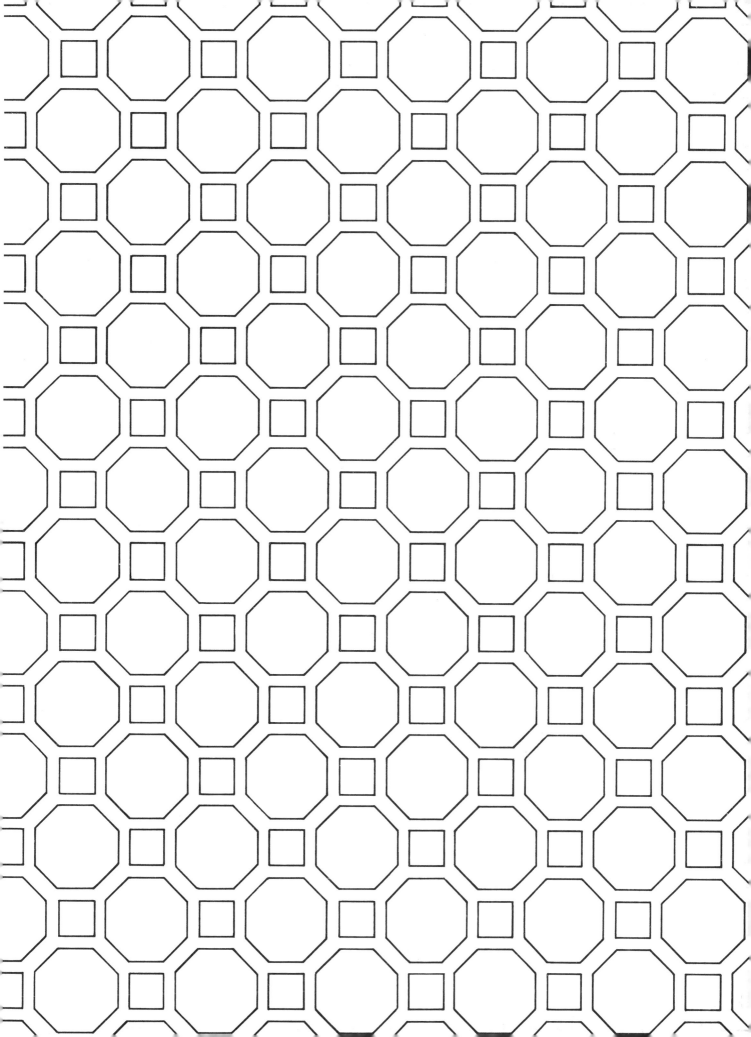

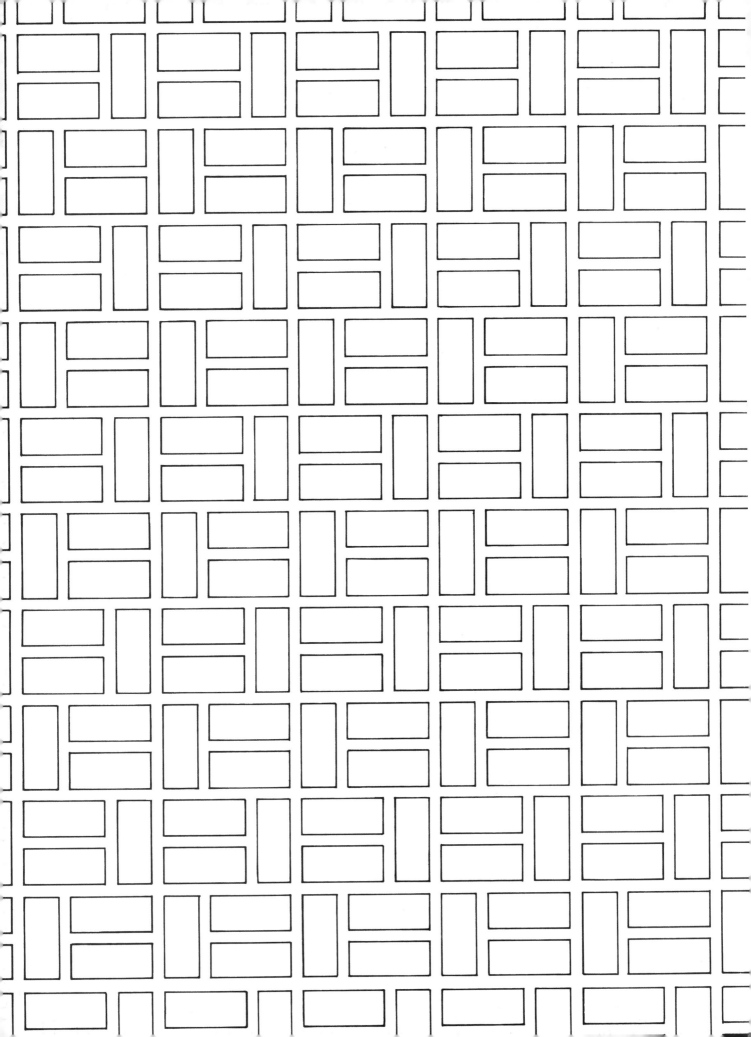

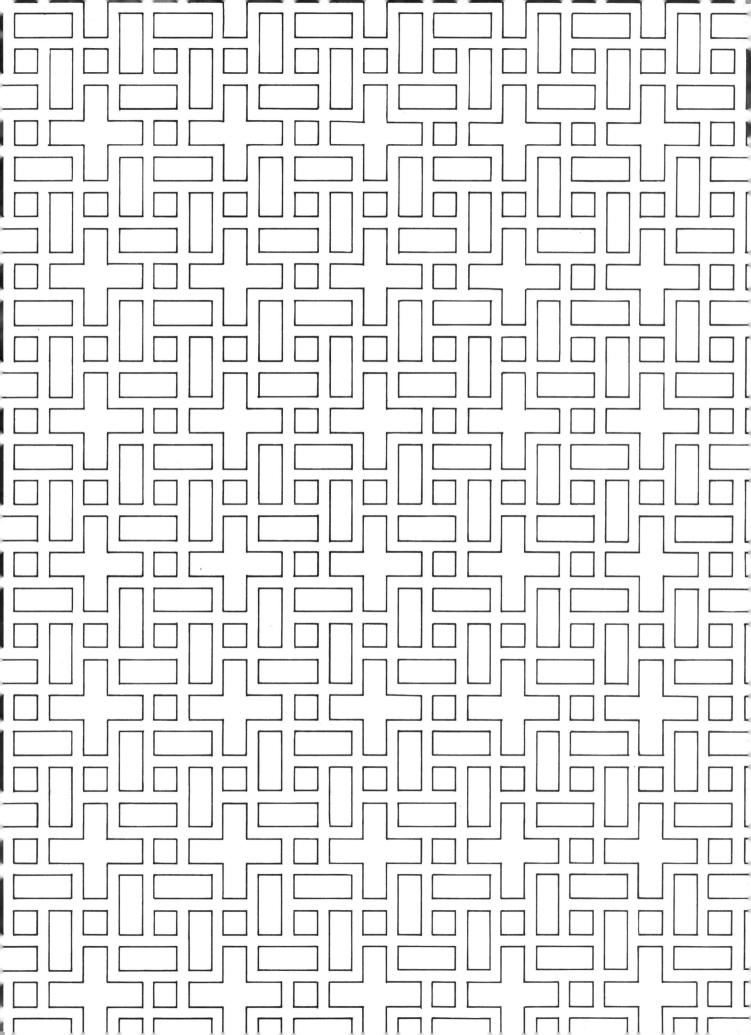

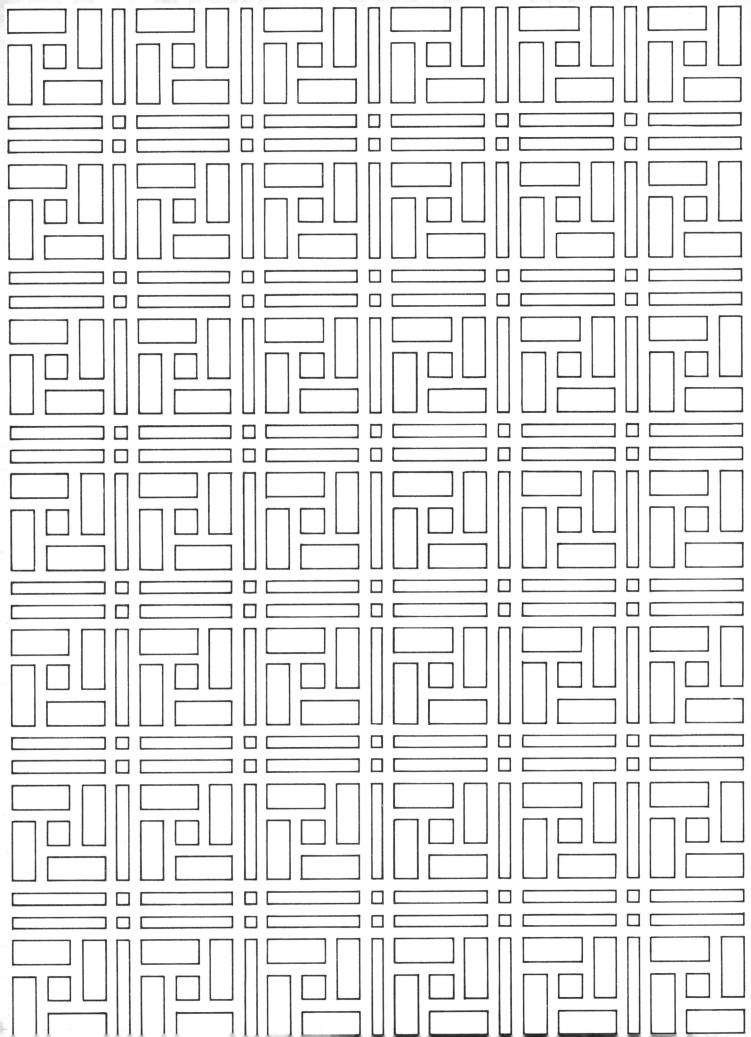

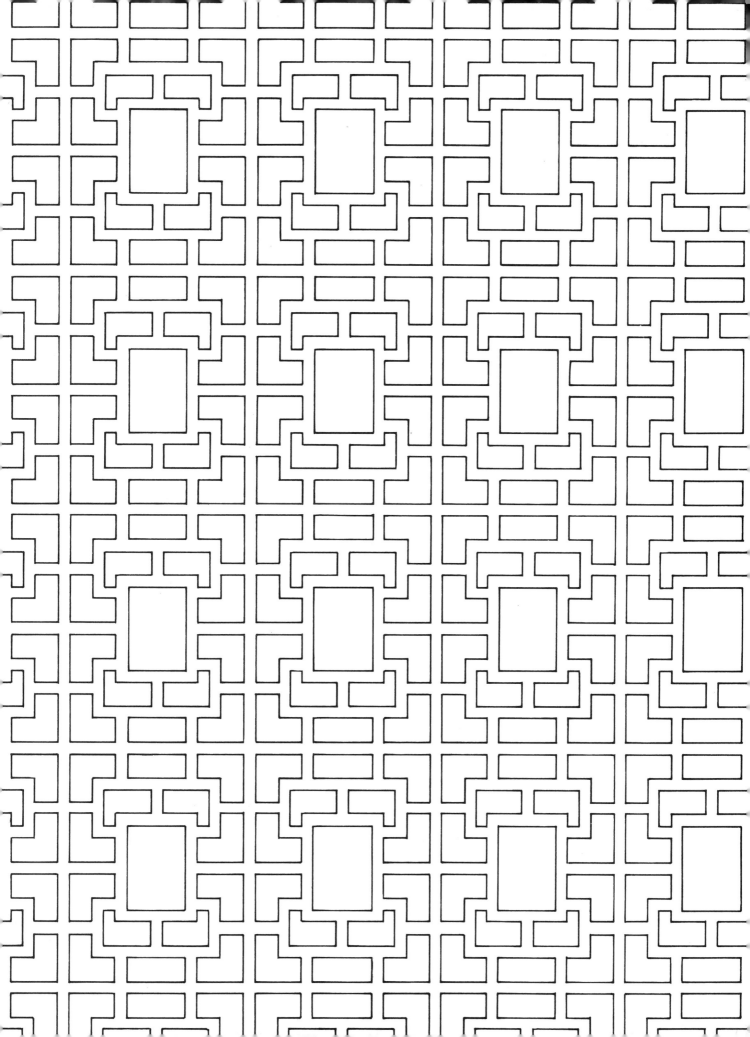

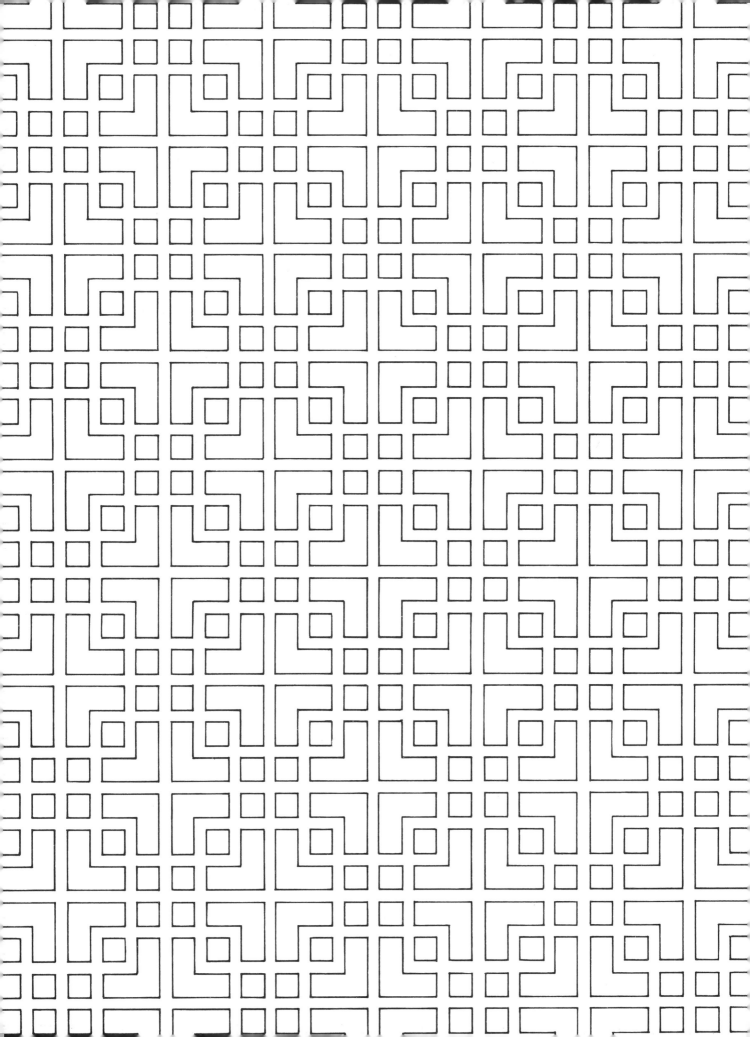

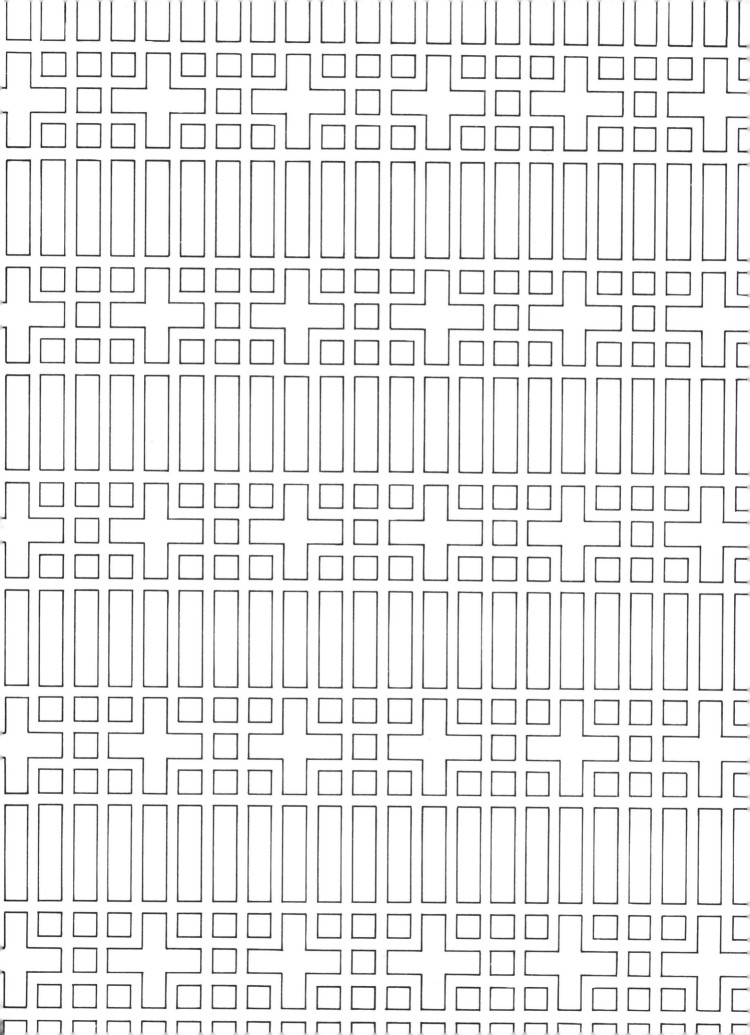

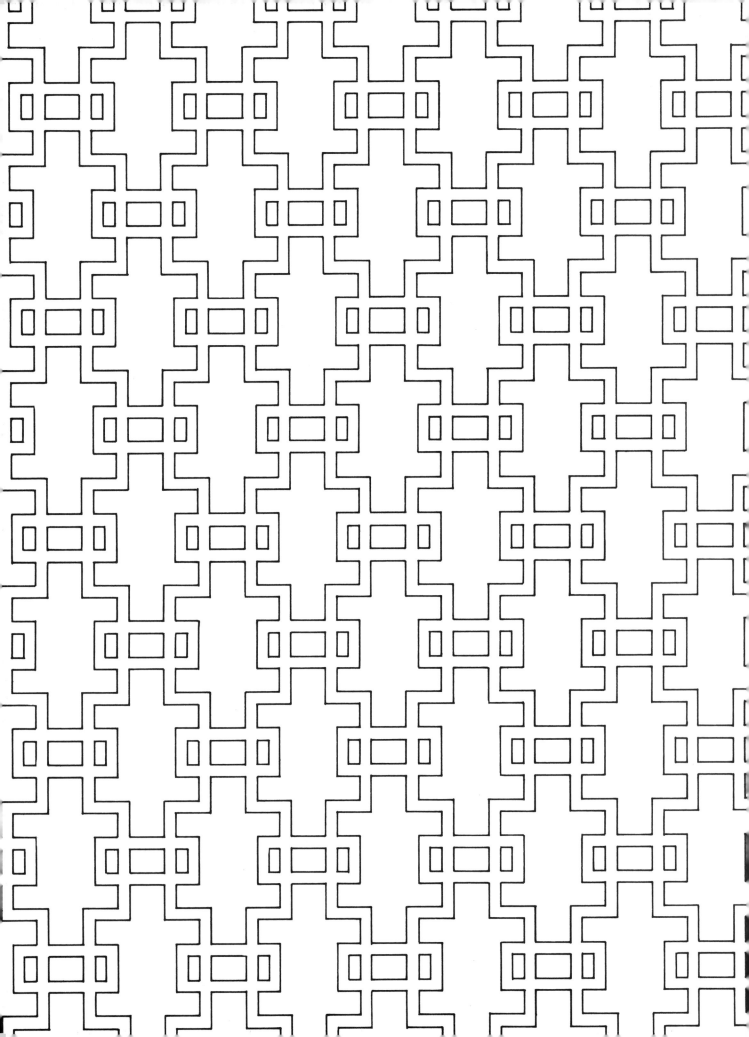

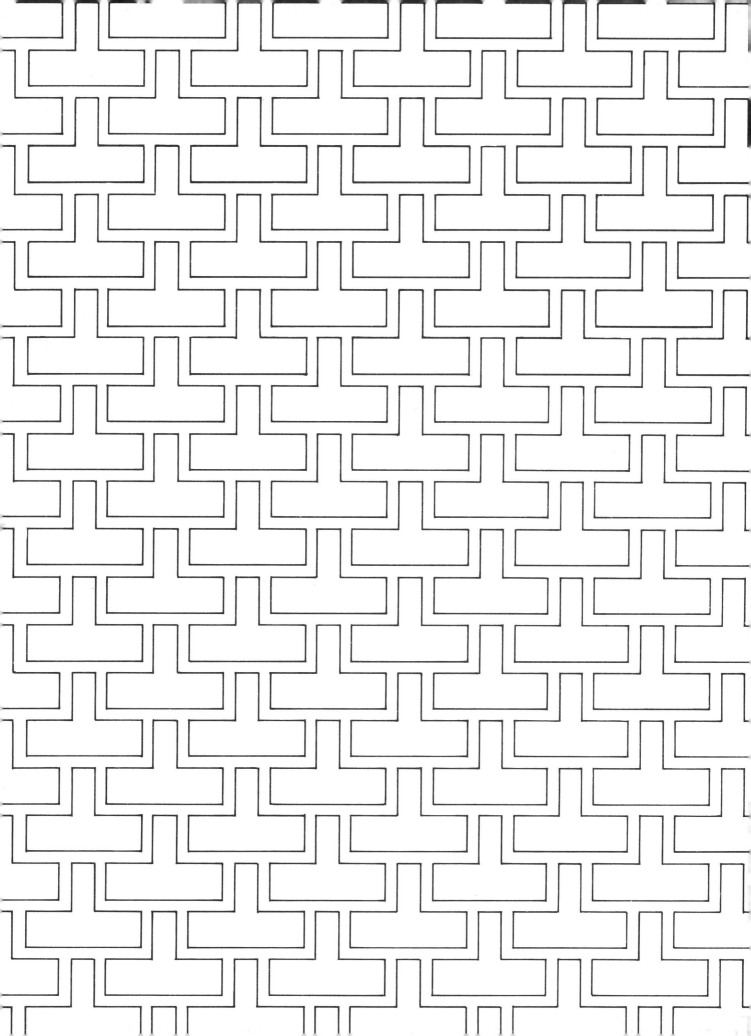

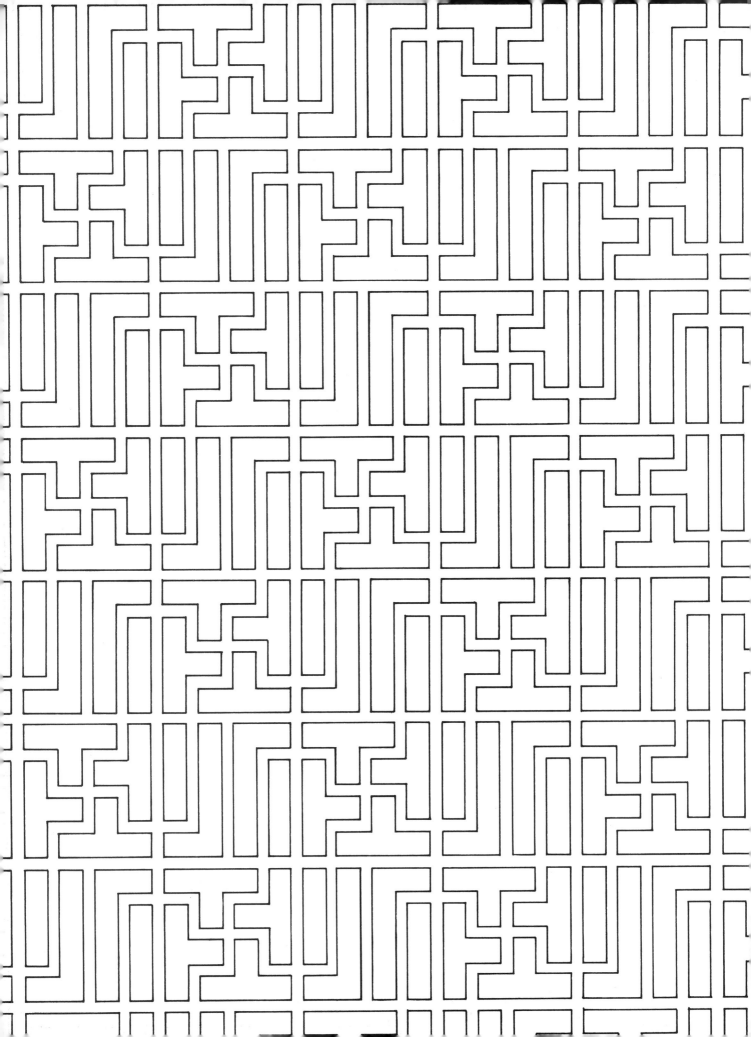

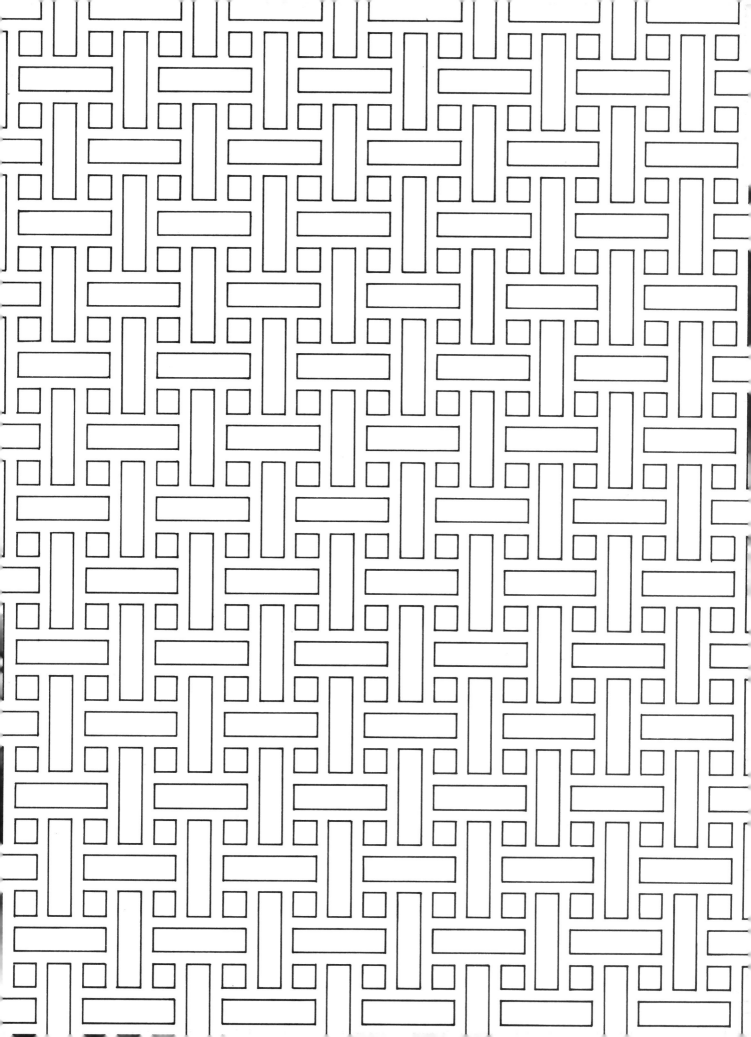

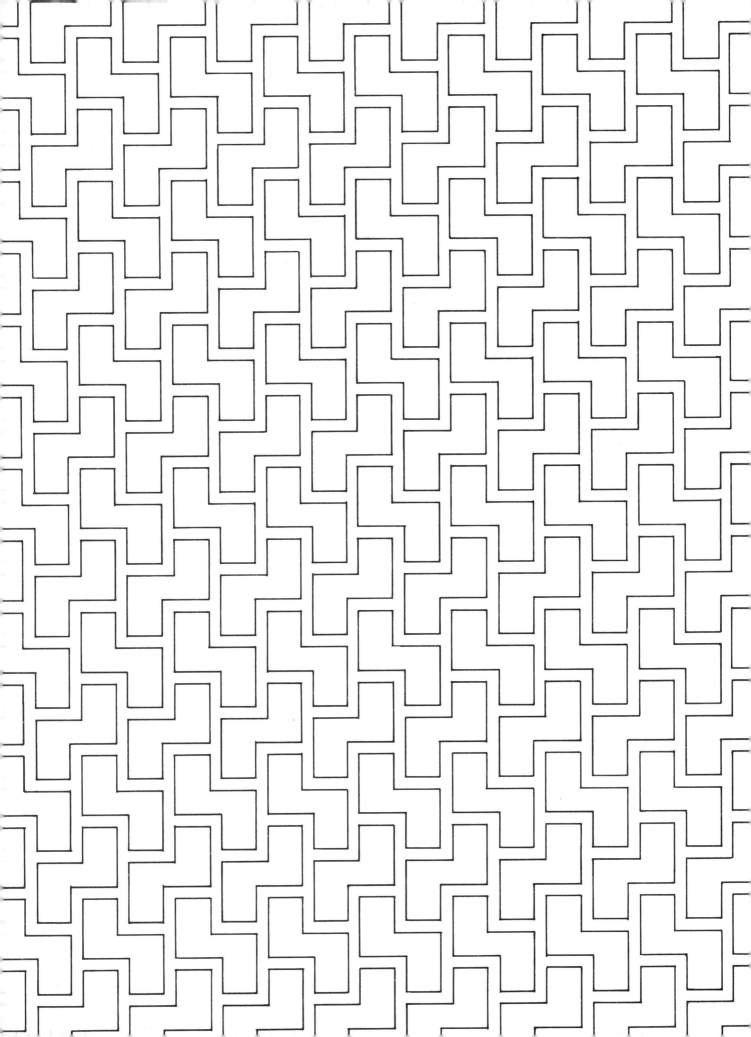

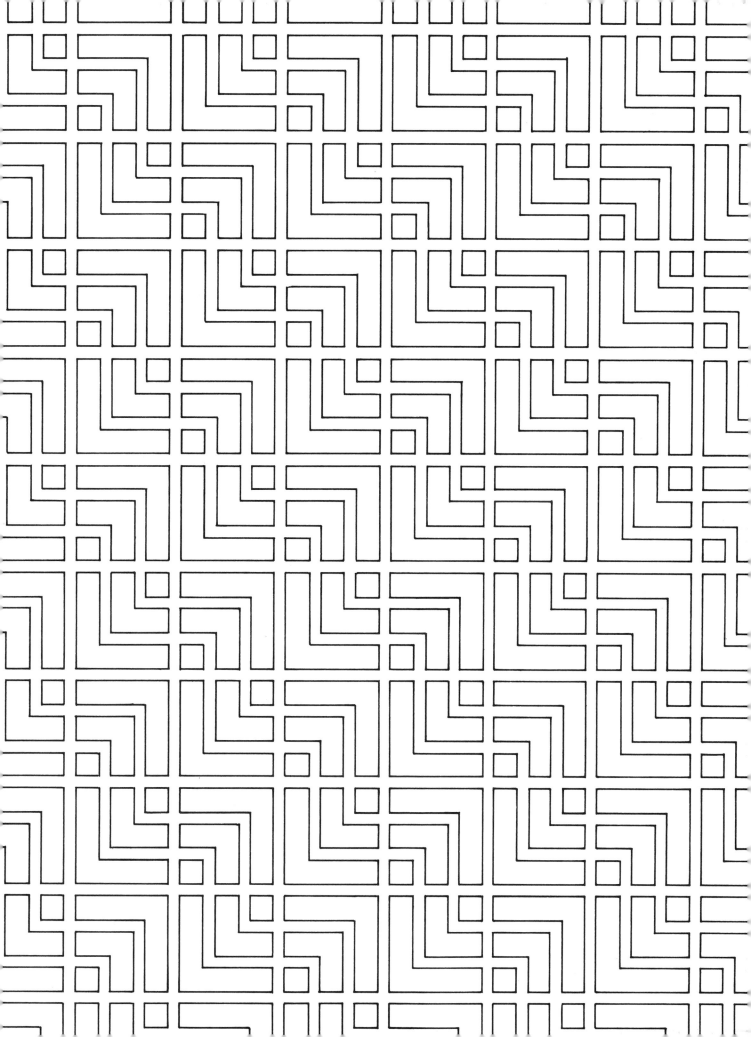

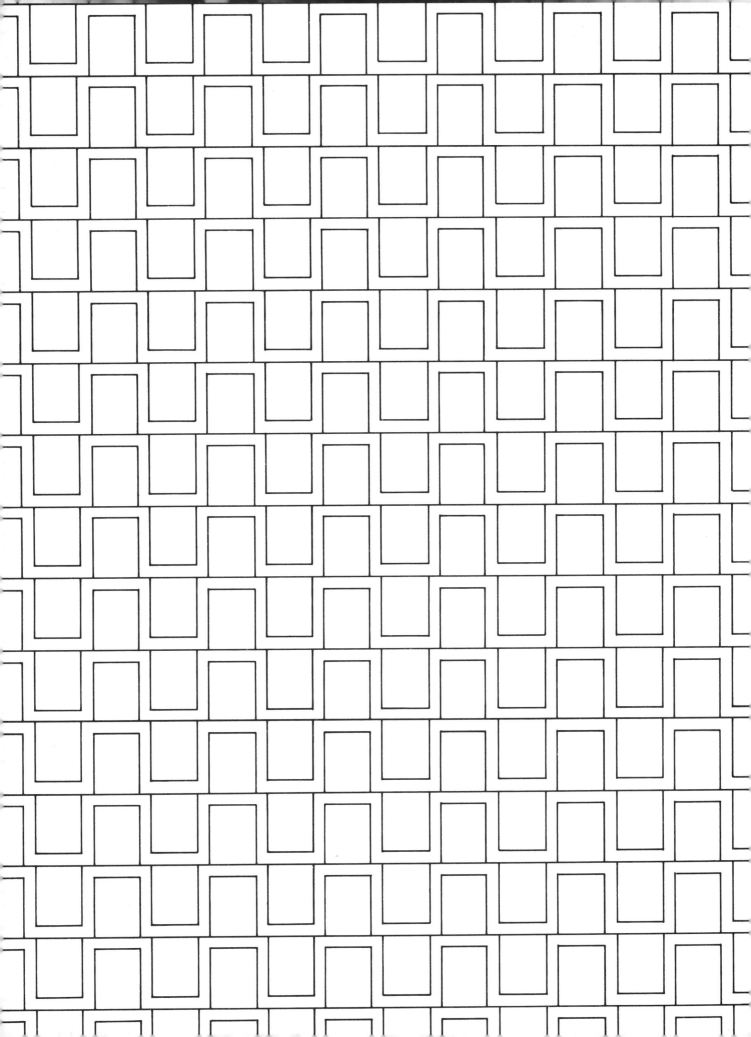

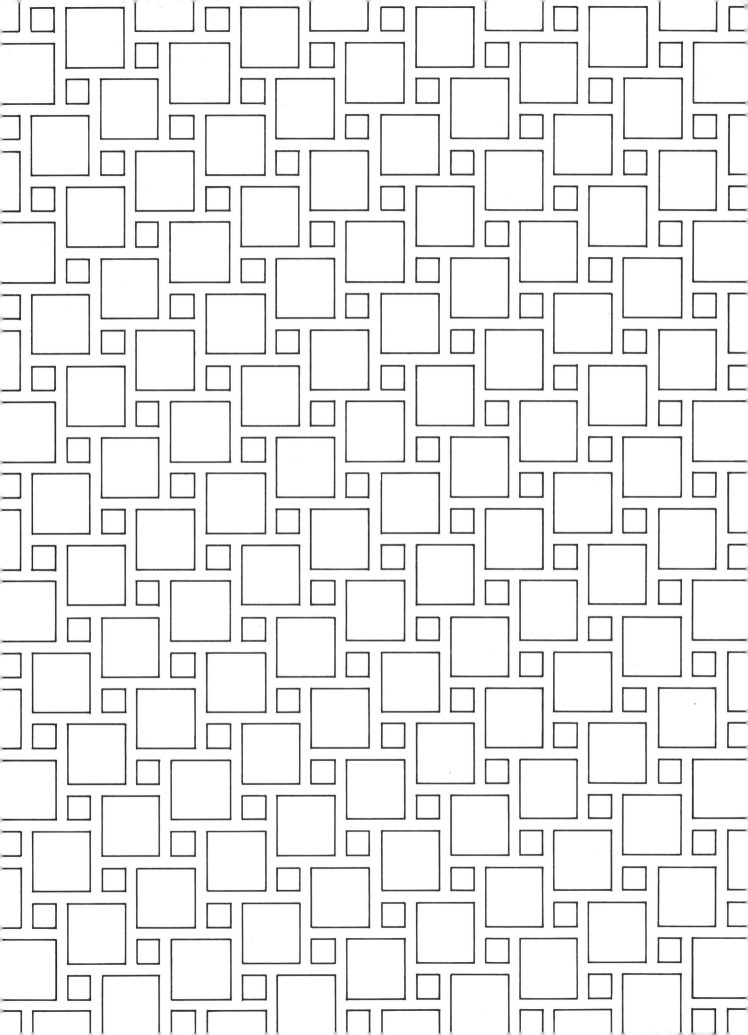

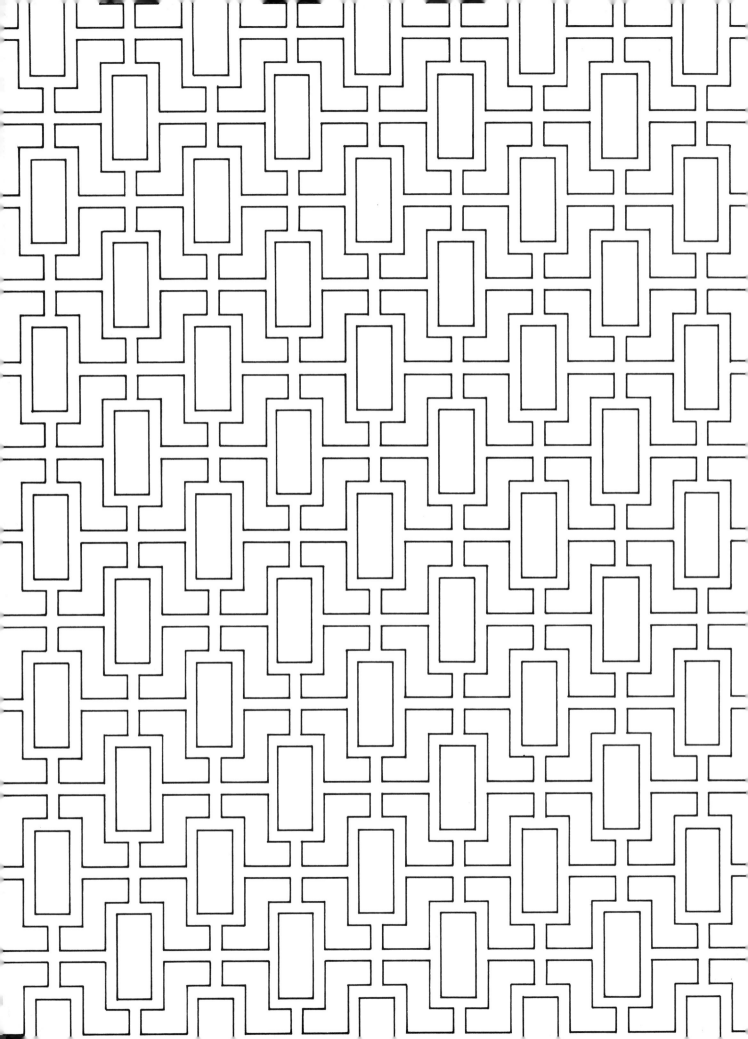

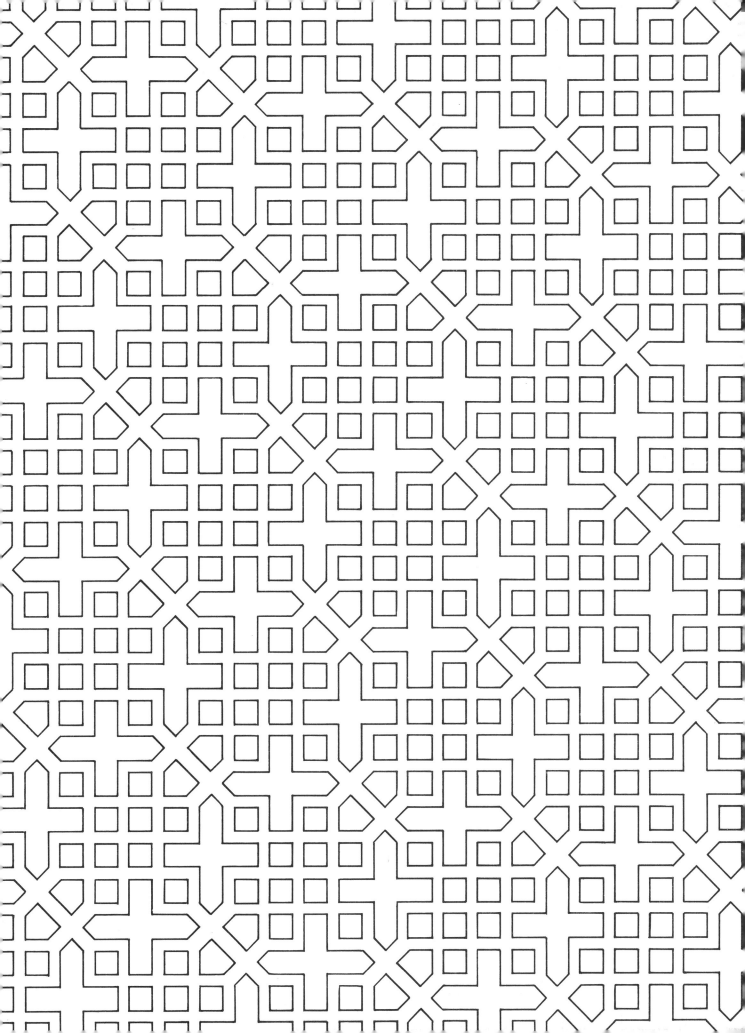

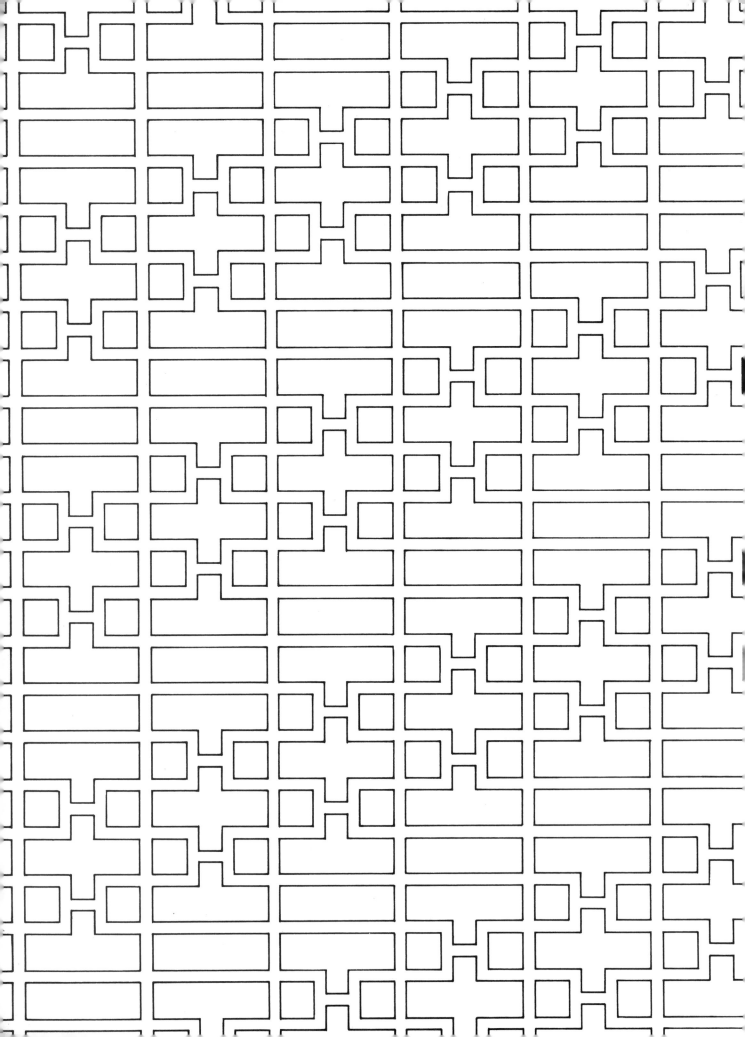